Draw • a • Dozen
with Basic Shapes

Directed Art Activities
for Young Children

E. Jane Rossi

Fearon Teacher Aids
a division of
PITMAN LEARNING, INC.
Belmont, California

HAGER

Edited by Carol Whiteley and Peter R. Cross

Design by Paul Quin

Illustrations by E. Jane Rossi

ISBN-O-8224-2350-2

Printed in the United States of America

1. 9 8 7 6 5 4 3 2 1

Contents

Introduction

I wrote this book at the request of many elementary teachers with whom I have worked. They had seen surprisingly mature work done by my young children who had learned and used a simple step-by-step drawing process involving the use of very simple basic shapes.

These shapes are even familiar to kindergarten children, and the ways of using them in drawing are very easily learned. Children drawing with basic shapes are motivated by success and pride in accomplishment. Because the process is virtually failure-proof, **every** child experiences success, not just a few.

Positive feelings and satisfying drawings are not the only benefits of using this approach. After sharing the basic-shapes method with my colleagues, they told me how pleased they were with the skills their children acquired in listening carefully, exercising perceptual abilities, measuring, estimating, and using orientation and position terms. Of course, they also got a lot of reinforcement in the names and nature of many basic shapes.

My basic-shapes approach to drawing was originally developed to be used once a week and on that basis this book was similarly organized. It contains drawing projects for twelve weeks, arranged in order of increasing difficulty. The technique is applicable to a range of grades, and the older children can experiment more with variations and embellishments on the basic patterns. Special students also find the structured nature of the drawing projects helpful.

There are four parts to each project. The first, always on a single removable MAKEMASTER® sheet, is a sketch of the animal in a natural setting. I recommend that you make copies of this page for the children to color. The pattern can also be enlarged by projecting with an opaque or overhead projector and re-tracing. Discuss this picture with the children, asking if they see any shapes in it they recognize. In the early projects, this step will also give you an idea of the children's knowledge of the various common shapes. (A list of common shapes is included at the back of the book, and can be enlarged or duplicated for the class.)

The second part of the project is a dot-to-dot exercise. Duplicate it by removing the MAKEMASTER® sheet and running a copy for each child. Read the directions to the children if necessary. This exercise reinforces a feeling for the overall shape of the animal. After children have discovered the animal by following the dots, they can compare their results to the introductory drawing, and add details while coloring their dot-to-dot. They should add those details which are **not** prepared shapes in the puzzle that follows, such as line-features on the bird's feet. At this point, you can remind the children of some of the shapes which are obvious in the overall configuration of the animal.

The third part of the project is a cut-and-paste animal puzzle. The pieces for this puzzle are usually found on one MAKEMASTER® sheet, occasionally on two. The puzzle can be assembled on any large art paper, pieces of butcher paper, or similar material that is white or light in color. This paper should be no smaller than 9 x 12 inches. The emphasis in the cut-and-paste puzzle is on readily-named basic shapes which may be geometric shapes; outline shapes of common objects such as eggs, peanuts, or apples; or an occasional letter or number shape. Sometimes **part** of a shape is used for one feature of an animal, but in such cases the whole shape is outlined with dots. Children will cut out only the part to be used along the solid lines, but in the process they can see the whole shape and understand that a segment of it has a particular appearance.

Make sure children see and use the small key drawing on the puzzle page. Read the directions to them if necessary. You may want to add even more specific directions for some groups. Encourage children to talk about what they are doing as they are doing it, either to you or to a partner or small group. This gives them more practice in using the shape terms and in expressing the step-by-step process.

The cut-and-pasted animal can be colored; or, if done on heavy-enough paper, it can be cut apart along the shape lines and made into a permanent puzzle. Children can take such a puzzle home and reassemble it for their parents or other adults, using the shapes names to tell what they are doing.

The fourth part of each project is the step-by-step drawing. There are several ways to handle this activity. You can duplicate the MAKEMASTER® page so that the children see and imitate the step-by-step evolution of the animal as you read the directions. Or, you can present only verbal directions and the children can take additional support from looking at their cut-and-paste puzzles, at an evolving drawing you put on the blackboard, or at a similar large-scale flow-pen drawing you do on an art easel. Or, you may want to see how well the children can do by attending carefully to verbal directions alone. In this case, particularly on earlier lessons or difficult parts of later lessons, you may want to amplify the directions given in the book, adding specific position and orientation details. In short, the number and kind of directions for this activity can and should be tailored to the needs of the group.

I have found that what works best is to urge children to draw decisively without undue concern for absolute accuracy, using black crayons. The use of pencils invites an over concern for exactness and erasing. It helps to read each step slowly and clearly, and to allow plenty of time between steps. Urge children who are unhappy with their drawings to finish anyway and to try again. When the drawing is finished, children will want to color it, and you can again discuss the basic shapes that were used.

That's all there is to it! Your children will enjoy their drawing projects, and after completing the dozen in this book will probably want to apply the same technique to other subjects. After working with the book **you** may want to work out additional drawing projects using the same method—I hope you do!

E. Jane Rossi

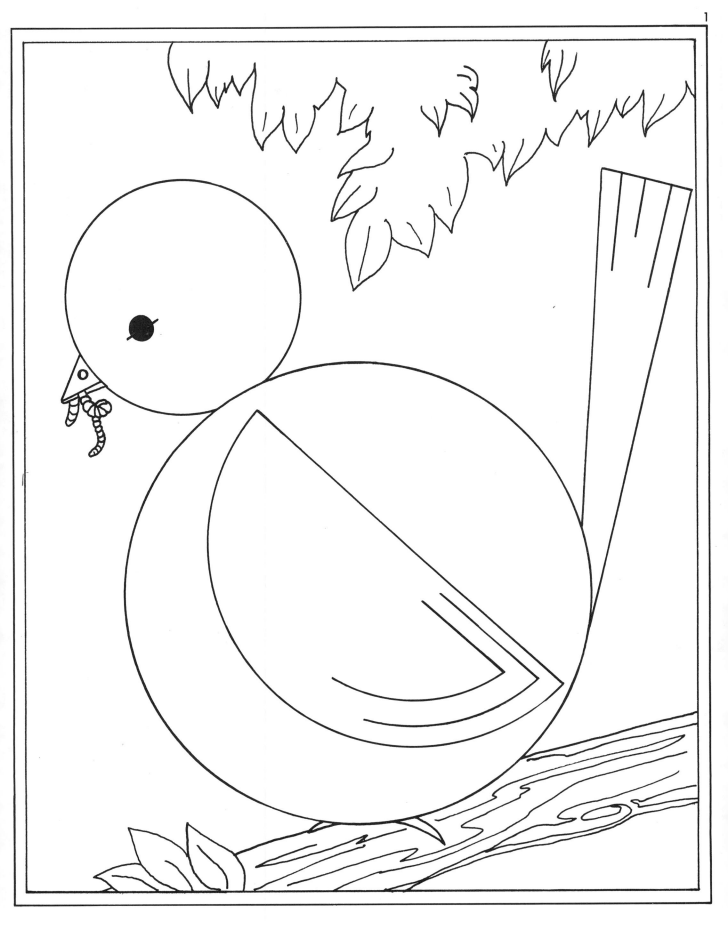

Bluebird

Dot • to • Dot Picture
Connect the dots to draw this animal.
Begin at 1, where you see a star.
Follow the dots in order.

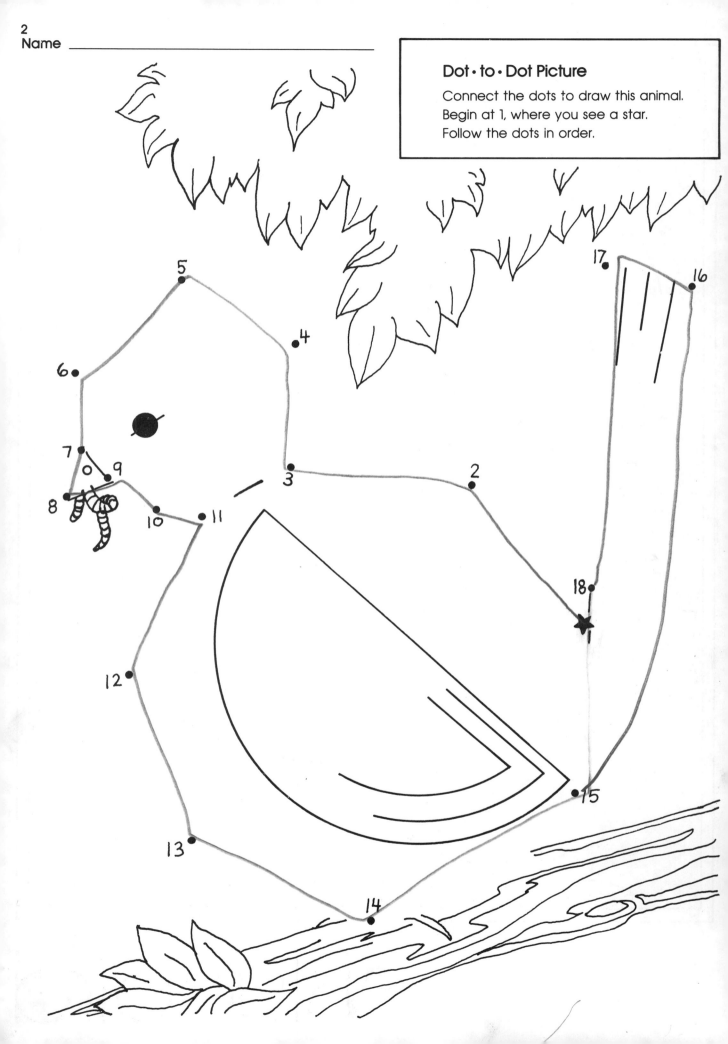

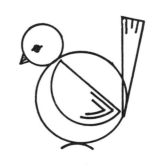

Bluebird Puzzle

Cut out the pieces of the puzzle. Look at the small picture that shows where the pieces fit together. First paste the big **circle** onto your paper. Next paste on the head. Then add the tail, beak, and wing. Draw a short **curved line** for the feet. Color your bluebird.

4

1. Draw a large **circle** near the center of the paper to make the bird's body.

2. Draw a circle about half as big as your large circle, touching the large circle, to make the bird's head.

3. Make the eye by drawing a very small circle. Draw a **straight line** through the eye, so a small part of the line sticks out on each side. Fill in the eye.

4. Draw a long thin **triangle** for the tail. Draw some lines at the end for feathers.

5. Draw a small triangle for the beak. Draw a short straight line and a **dot** for the bird's mouth and nose.

6. Draw a **half circle** for the wing. Put some lines on it for feathers. (Optional: **V**-shaped lines.)

7. Draw a short **curved line** for the feet.

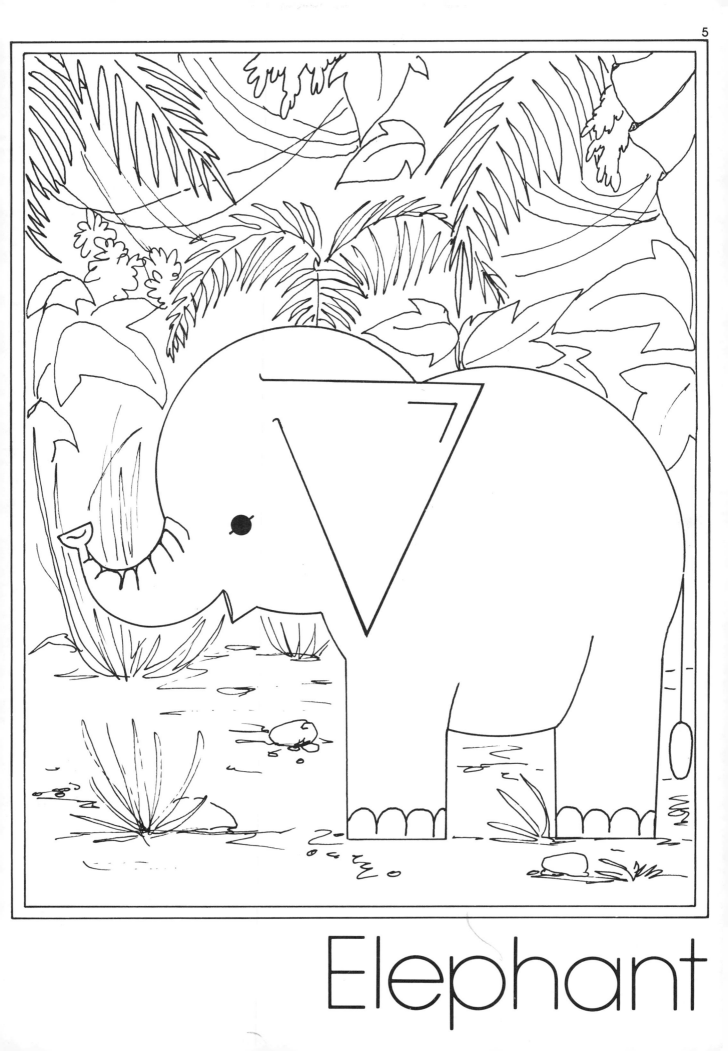

Elephant

6
Name _____

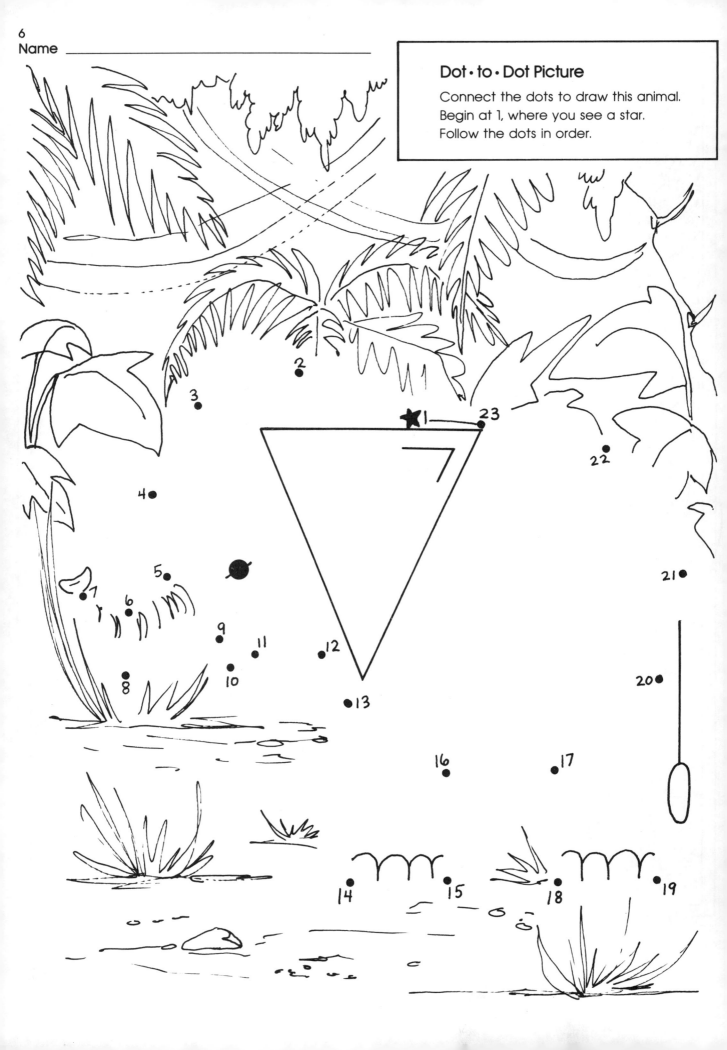

Dot · to · Dot Picture

Connect the dots to draw this animal.
Begin at 1, where you see a star.
Follow the dots in order.

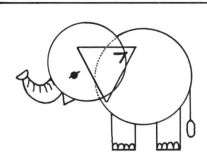

Elephant Puzzle

Cut out the pieces of the puzzle. Look at the small picture that shows where they fit together. First paste the bigger **circle** onto your paper. Then paste on the circle for the head, overlapping the first one. Then add the **triangle** for the ear. Then add the trunk, mouth, and legs. Draw a **straight line** for the tail. Add the small **oval** at the end of this line. Color your elephant.

Copy both sides of this page.

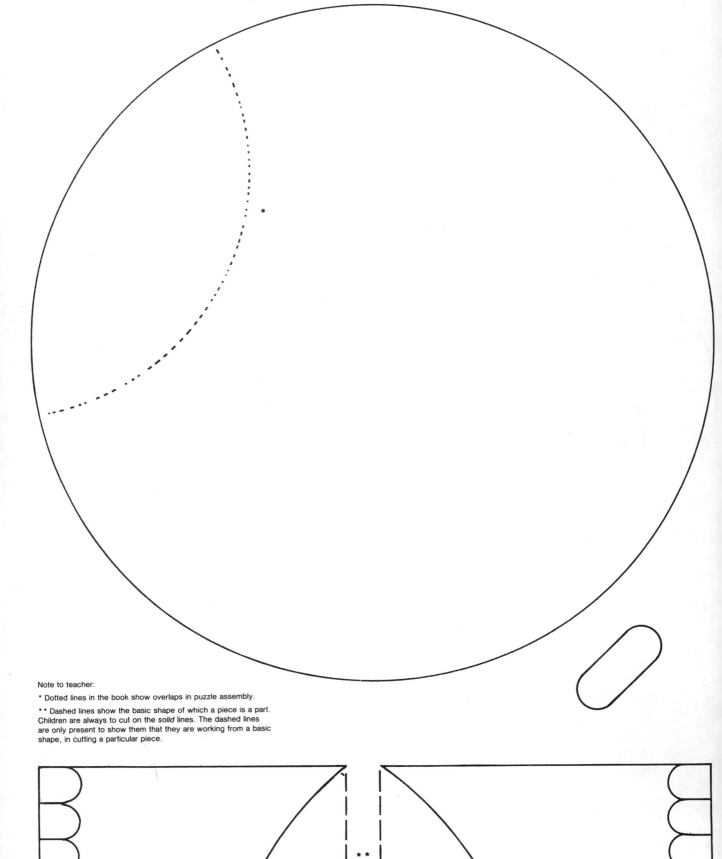

Note to teacher:

* Dotted lines in the book show overlaps in puzzle assembly.

** Dashed lines show the basic shape of which a piece is a part. Children are always to cut on the *solid* lines. The dashed lines are only present to show them that they are working from a basic shape, in cutting a particular piece.

How to Draw an Elephant

1. Draw a large **circle** near the center of your paper.

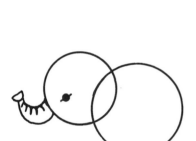

2. Draw a smaller circle overlapping it, for the head. Make a very small circle for the eye. Draw a short **straight line** through it so a bit sticks out on each side. Fill in the eye.

3. Draw two **curved lines** to make the trunk.

4. Draw a small **half circle** at the end of the trunk. Add some lines on the trunk for wrinkles.

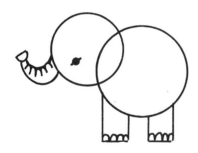

5. Draw a **rectangle** for the front leg. Draw another for the back leg. Make toes by drawing small half circles at the bottom of each leg.

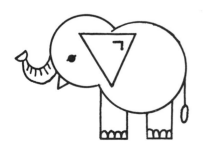

6. Draw a **triangle** for the ear. Add a sideways **V** to the ear. Draw a small triangle for the mouth. Draw a straight line with an **oval** at the end for the tail.

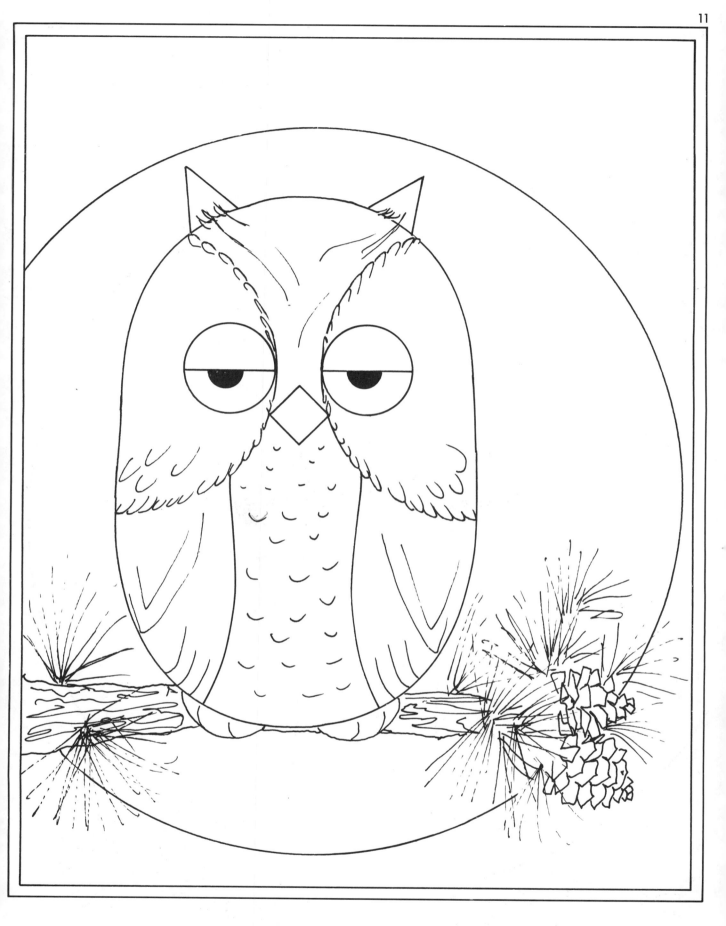

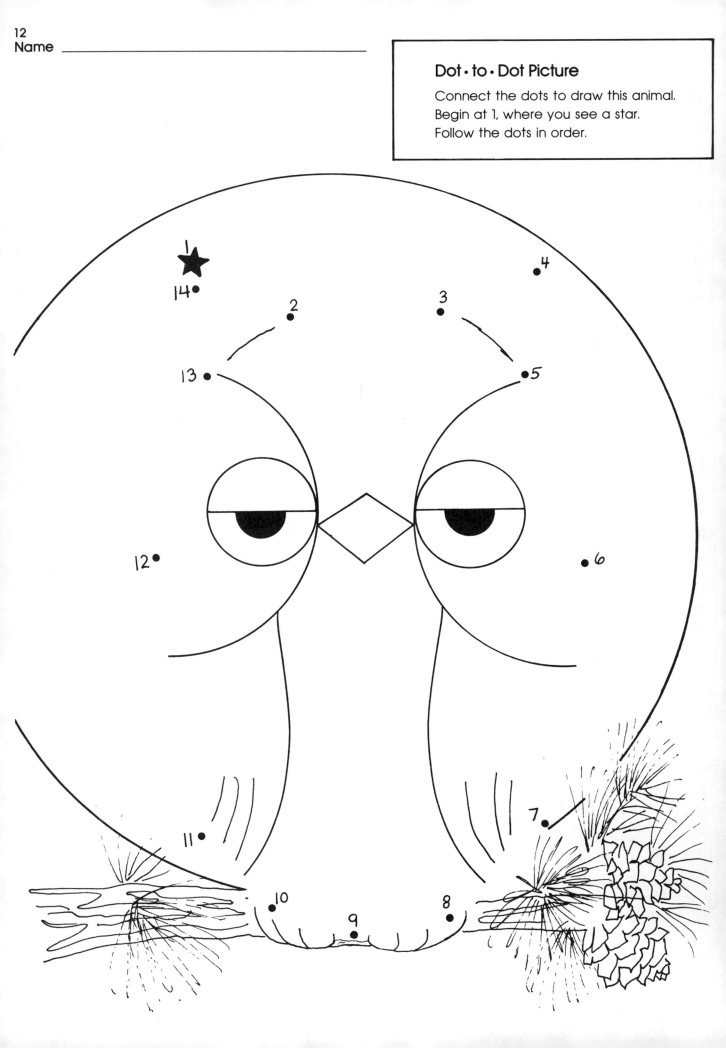

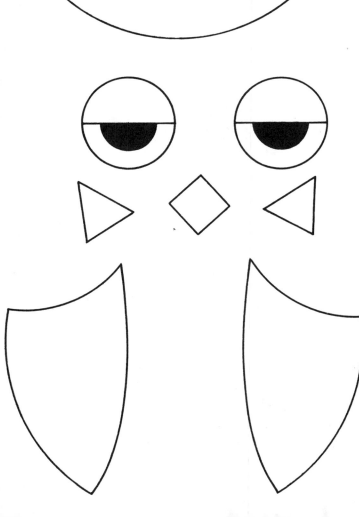

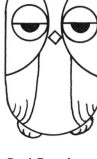

Owl Puzzle

Cut out the puzzle pieces. Remember to look at the small picture before you go on. Paste the large **oval** onto your paper to make the body. Paste on the **half circles** to make rings around the eyes. Then paste the **circles** on the half circles for the eyes. Next add the ears, nose, and feet. Paste on the wings. Add **curved lines** for feathers. Color your owl.

RIGHT LEFT

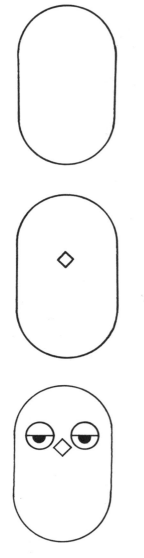

How to Draw an Owl

1. Draw a large **oval** near the center of your paper.

2. Draw a small **diamond** shape for the beak.

3. Draw two **circles** for the eyes. Draw a **straight line** inside each of the eyes, from side to side, dividing the eye in half.

4. Find the middle of each of these dividing lines. Right under the middle of each line, and touching the line, draw a small **half circle.** Fill it in.

5. Draw a large half circle around each eye, to show the rings around the eyes.

6. Draw two **triangles** for the ears.

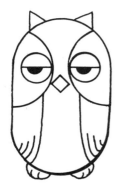

7. Draw **curved lines** below the half circles to show the wings. Draw a few more curved lines for feathers.

8. Draw two short curved lines for feet. Add two lines on each foot for the talons.

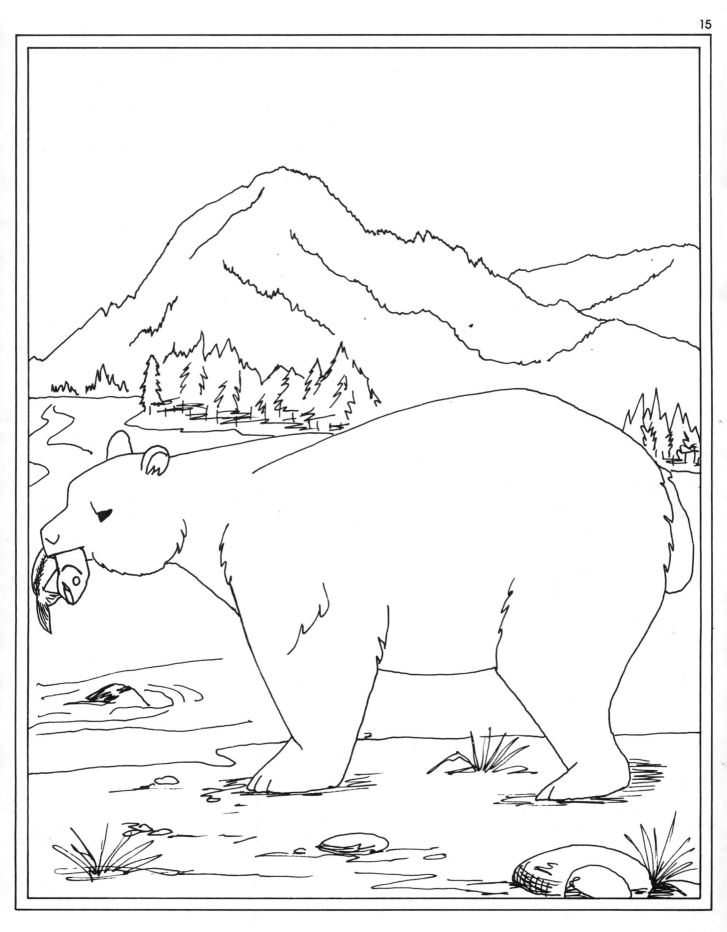

Bear

16
Name _____

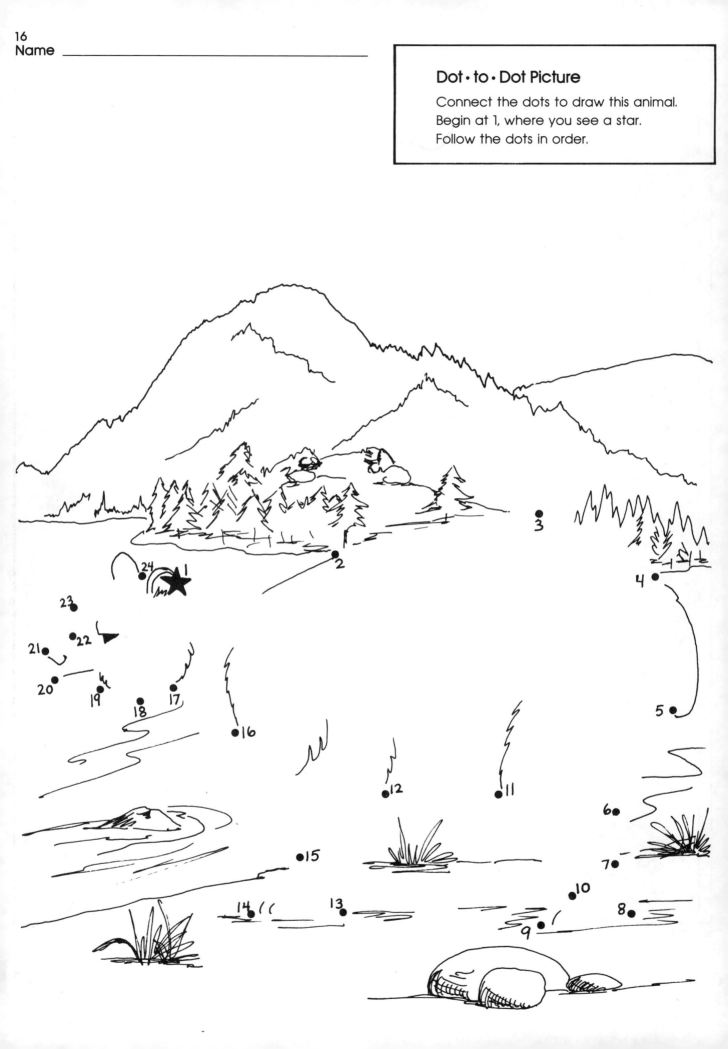

Dot·to·Dot Picture

Connect the dots to draw this animal.
Begin at 1, where you see a star.
Follow the dots in order.

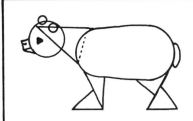

Bear Puzzle

Cut out each puzzle piece. Look at the small picture to see where the pieces fit together. First paste the **triangle** sideways on your paper. Then add the head and body. The head overlaps the tip of the triangle. The body overlaps the base (wide end). Draw a small triangle for the eye. Add the ears, mouth, legs, and tail. Color your bear.

Copy both sides of this page.

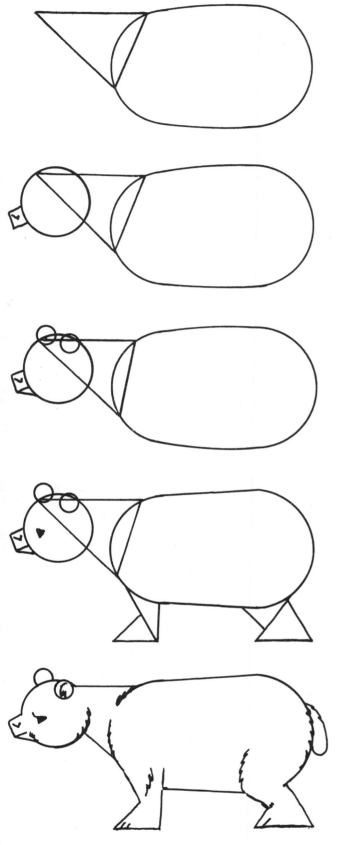

How to Draw a Bear

1. Draw a large **oval** for the body near the center of your paper.
2. Draw a sideways **triangle** for the neck.

3. Draw a **circle** that overlaps the point of the triangle, for the head.
4. Draw a small **square** for the nose. Put a small diagonal **L** on the nose.

5. Draw a **straight line** to make a small triangle for the mouth.
6. Draw two small circles for ears.

7. Draw a triangle for the front leg. Add a small triangle for the front toes.
8. Draw two triangles for the back leg and foot.
9. Draw a very small triangle for the eye. Fill in the eye.

10. Draw a small oval for the tail.
11. Draw **curved lines** for hair.

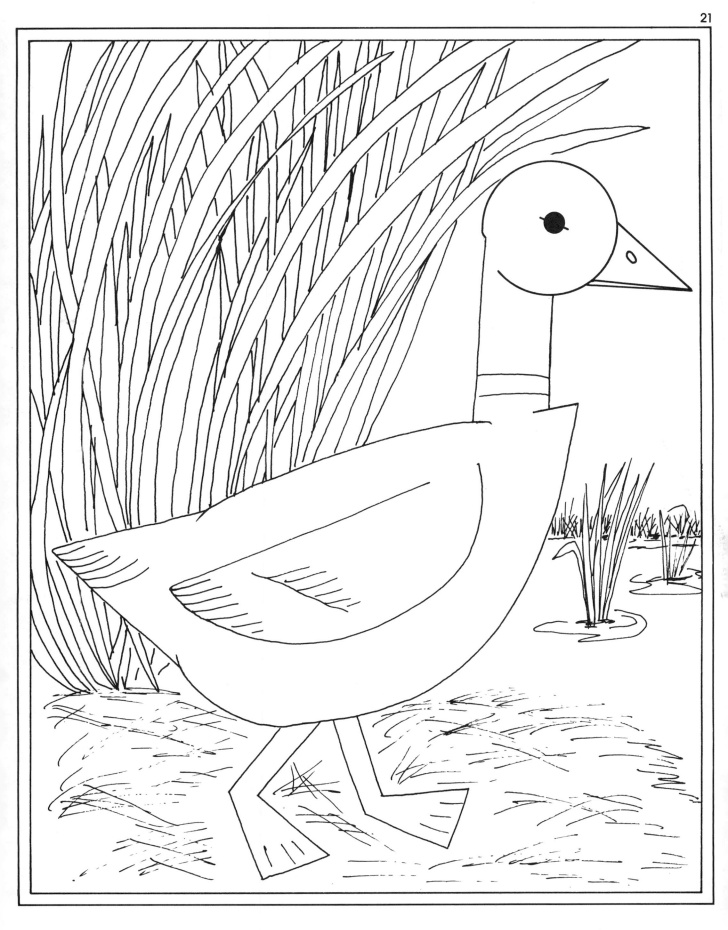

Duck

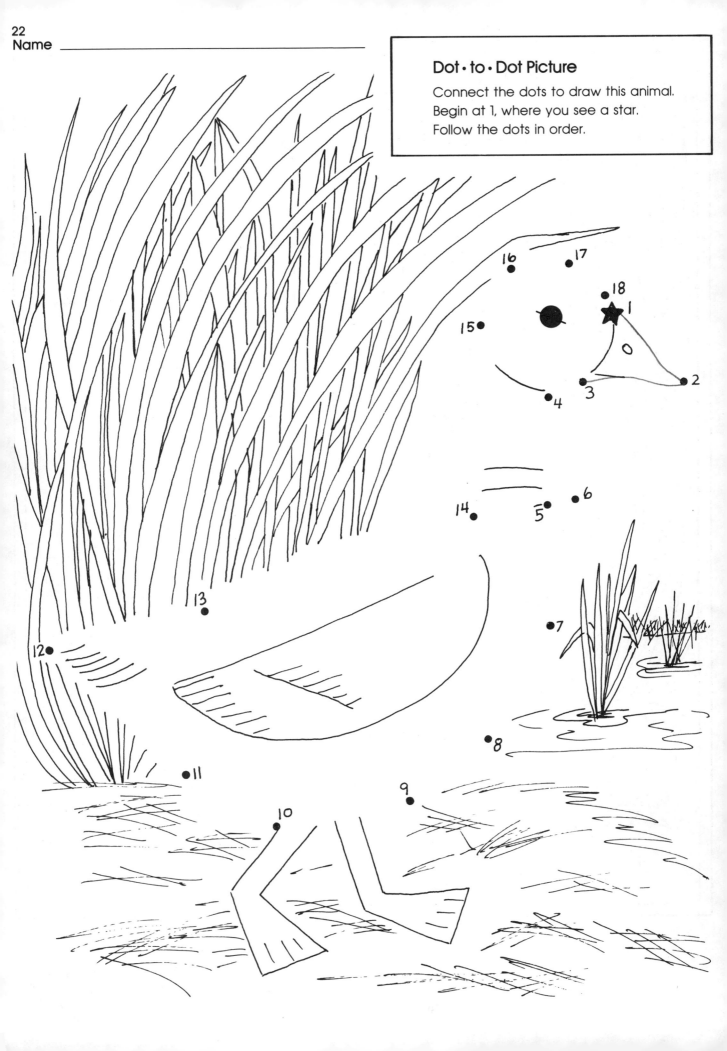

22
Name _____

Dot · to · Dot Picture
Connect the dots to draw this animal.
Begin at 1, where you see a star.
Follow the dots in order.

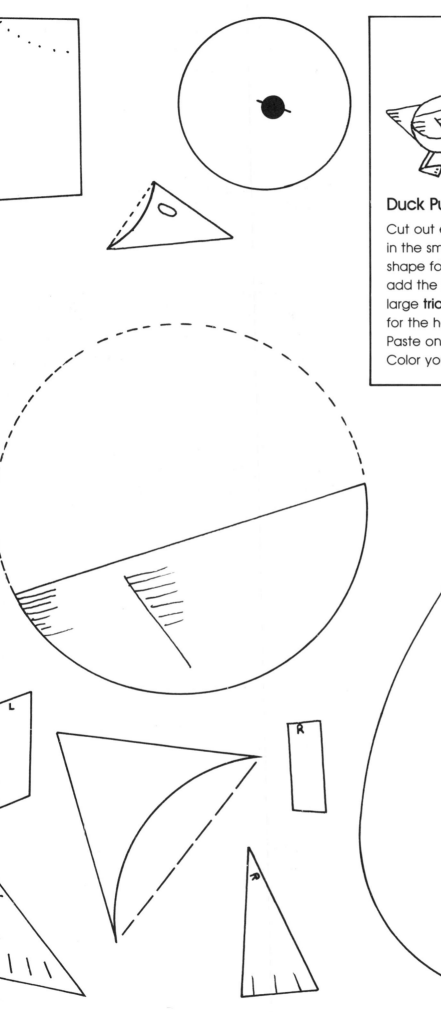

Duck Puzzle

Cut out each puzzle piece. Look at the duck in the small picture. Paste the large **teardrop** shape for the body onto your paper. Now add the fat **rectangle** for the neck and the large **triangle** for the tail. Paste on the **circle** for the head, overlapping the neck a little. Paste on the beak, wings, legs, and feet. Color your duck.

How to Draw a Duck

1. Draw a large **teardrop** shape for the body, near the center of your paper.

2. Draw a fat **rectangle** for the neck. Draw a large **triangle** for the tail.

3. Draw a **circle** for the head. Draw a triangle for the beak. Draw a small **oval** inside the beak for the nose.

4. Draw a very small circle for the eye. Draw a short **straight line** through it, so that a little piece of the line sticks out on each side. Fill in the eye.

5. Draw a **half circle** for the wing.

6. Draw two thin rectangles for the legs. Draw a triangle to make each foot.

7. Add some lines for feathers on the wings and tail, and for the toes on the feet.

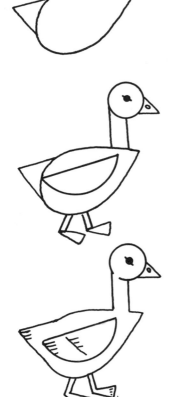

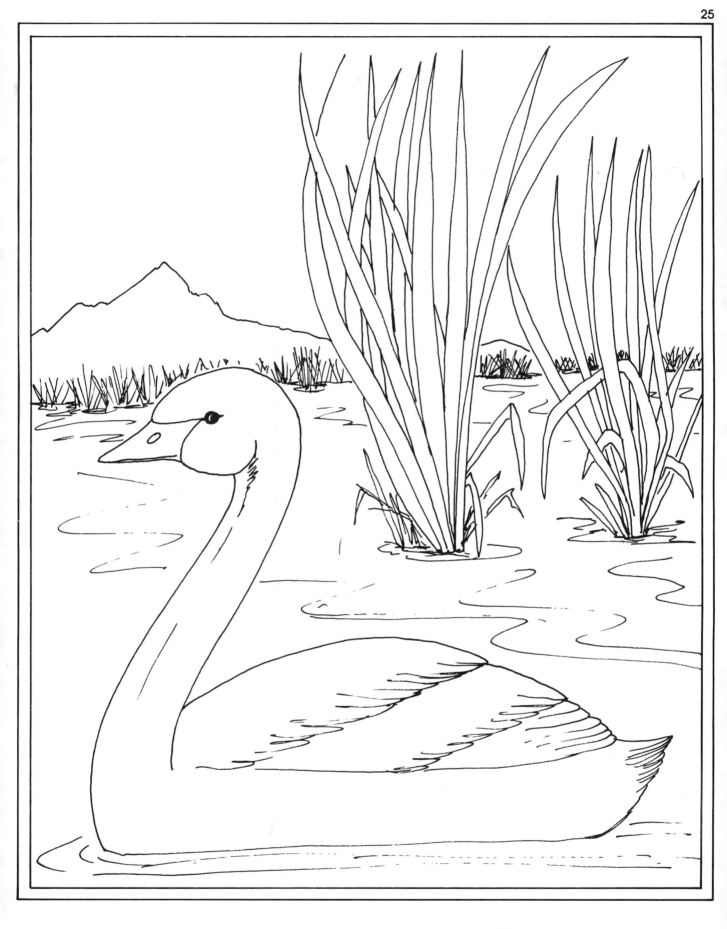

Swan

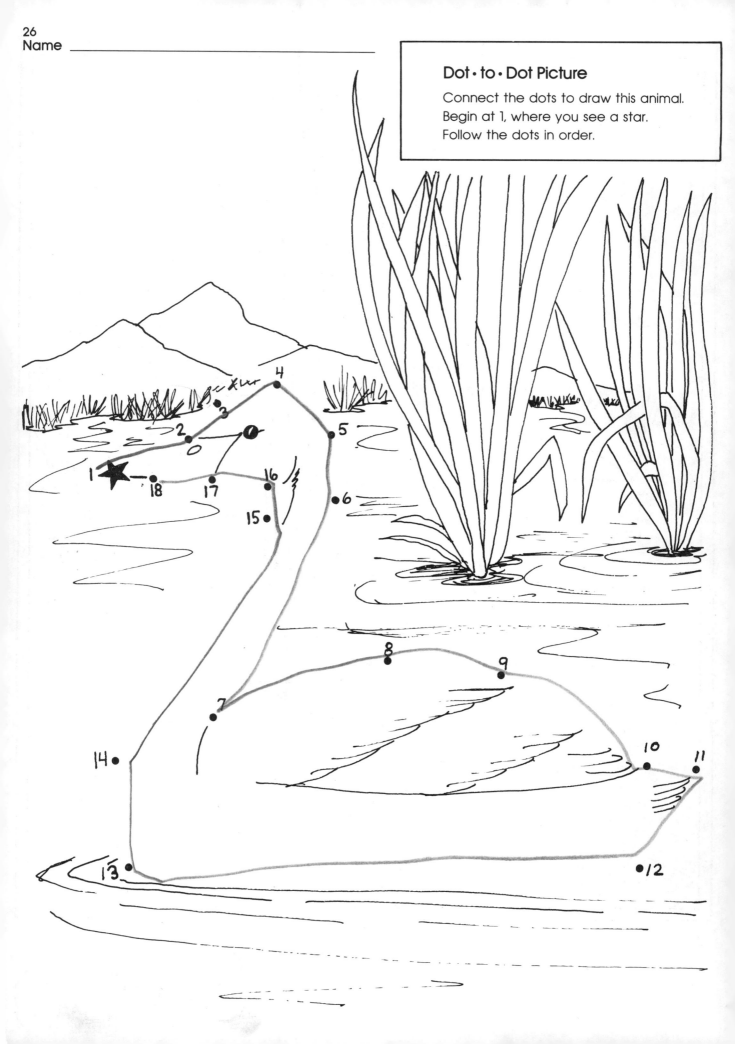

Dot·to·Dot Picture
Connect the dots to draw this animal.
Begin at 1, where you see a star.
Follow the dots in order.

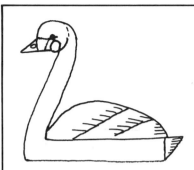

Swan Puzzle

Cut out each puzzle piece. Look at the swan in the small picture. Paste the big **2** on your paper, right-side-up. Add the **half circle** piece to finish the body. Paste on the head. Draw an eye, with a **straight line** through it. Fill in the eye. Add the **triangle** for the tail. Put on the beak. Color your swan.

How to Draw a Swan

1. Near the center of your paper, draw a big **2**, like the one in your puzzle. The bottom of it must be extra long.

2. Then draw a **curved line** to make a half circle, on top of the bottom part of the 2.

3. Draw a **circle** for the head overlapping the top of the 2.

4. Draw a very small circle for the eye, adding a **straight line** and filling it in as you have done before.

5. Draw a **triangle** for the beak. Add a small **oval** for the nose.

6. Draw a **V** sideways between the eye and the beak triangle.

7. Draw lines on the back for the wings and feathers.

8. Draw a small triangle for the tail.

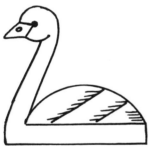
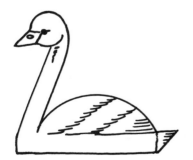

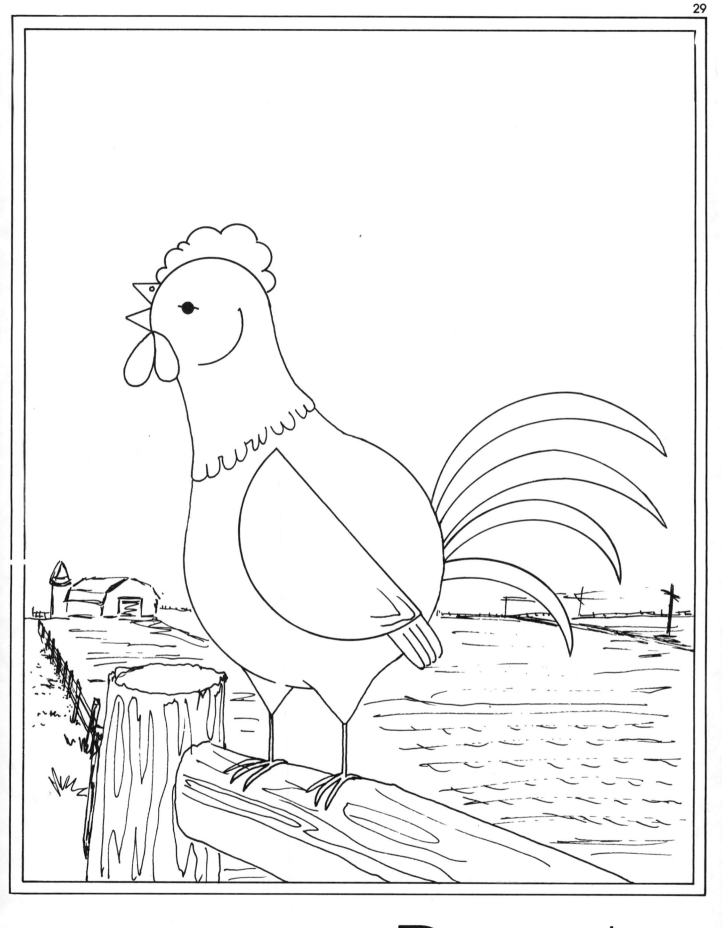

Rooster

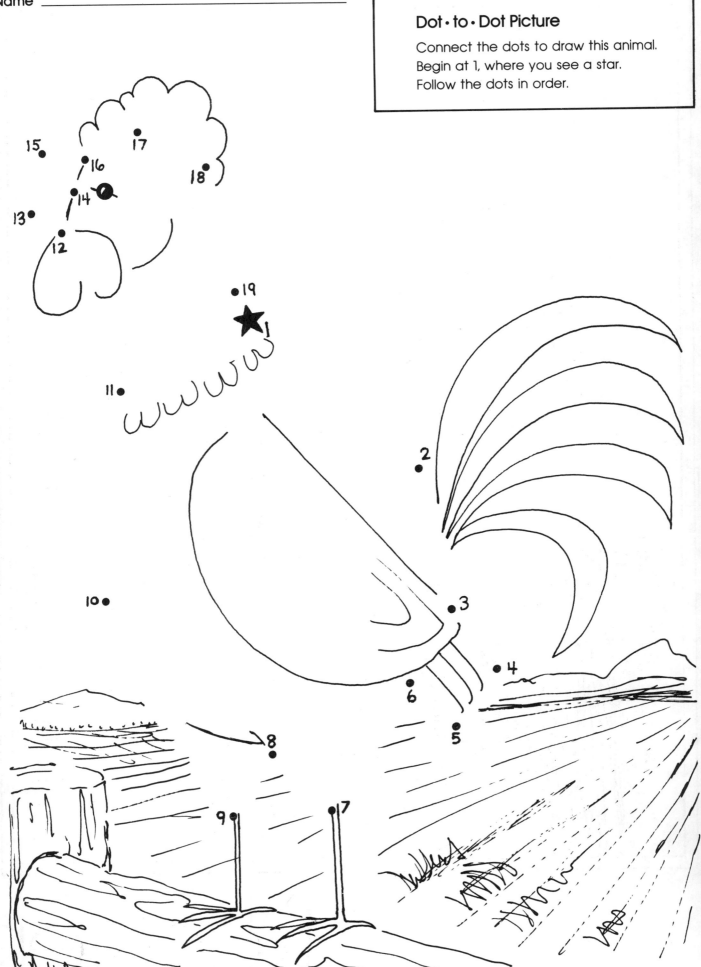

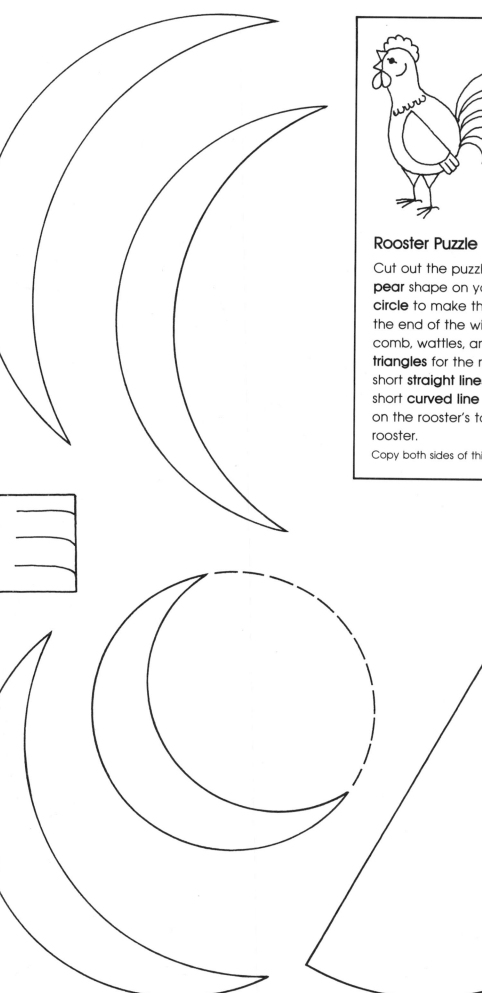

Rooster Puzzle

Cut out the puzzle pieces. Paste the large **pear** shape on your paper. Paste on the **half circle** to make the wing. Add the feathers at the end of the wing. Paste on the rooster's comb, wattles, and beak. Put on the **triangles** for the rooster's legs. Draw three short **straight lines** for each foot. Draw one short **curved line** for each back toe. Paste on the rooster's tail feathers. Color your rooster.

Copy both sides of this page.

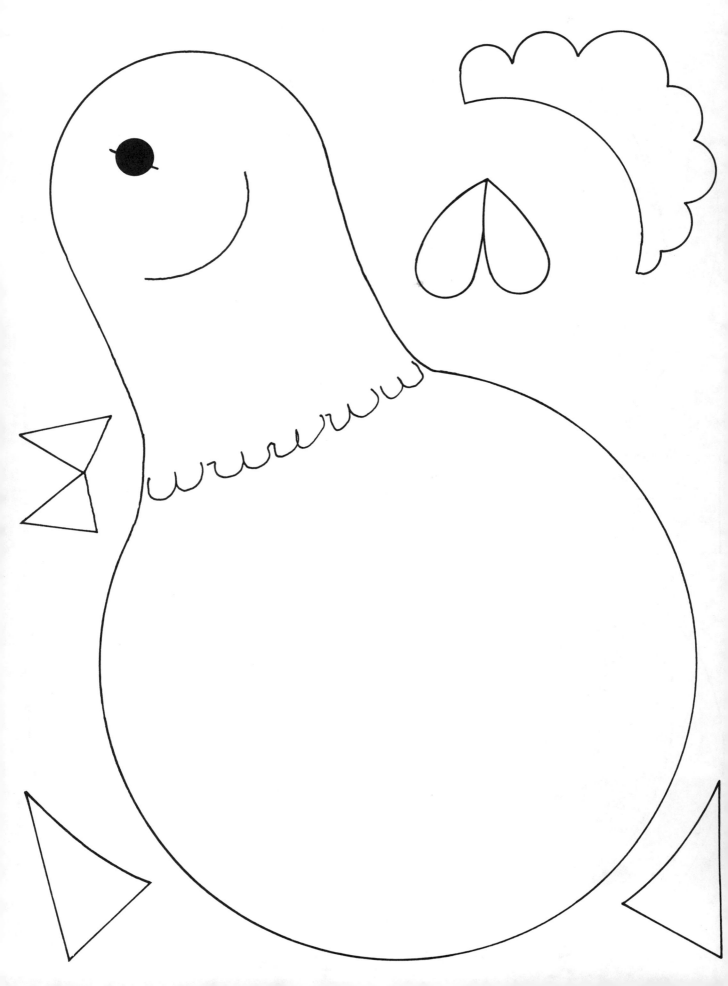

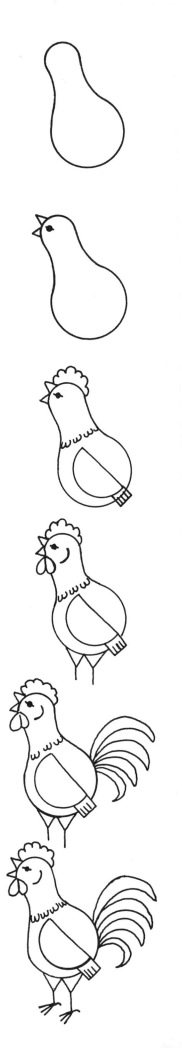

How to Draw a Rooster

1. Draw a **pear** shape near the center of the paper.

2. Draw the eye as you have done before.

3. Draw two small **triangles** right next to each other, to make the beak.

4. Draw a **half circle** for the wing. Add a small **square** with lines for feathers.

5. Draw a series of bumps on the top of the head for the comb. Draw the letter **W** to make neck feathers.

6. Draw two **teardrop** shapes under the beak, to make the wattles. Add a small **crescent** to suggest the shape of the head.

7. Draw two triangles and short **straight lines** down from them to make the legs.

8. Draw several thin crescents together for the tail.

9. Draw three straight lines at the bottom of the legs, to make the feet. Add a short **curved line** to each foot, for the back toes.

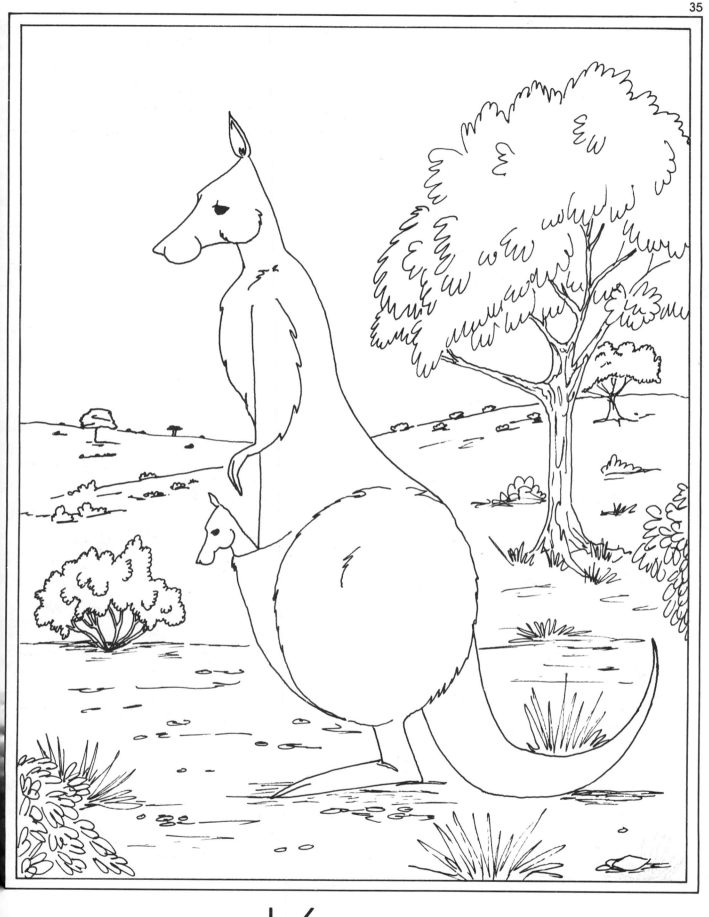

Kangaroo

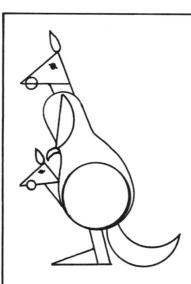

Kangaroo Puzzle

Cut out the pieces. First paste the large **pear** shape onto your paper. Then paste on the **circle** over the bottom of the pear to make the haunch. Add the neck, head, and mouth. Draw an eye like before. Add the ear, arm, and paw. Paste on the leg, foot, and tail. Add the baby kangaroo. Color your kangaroo.

Copy both sides of this page.

More Kangaroo Puzzle Pieces

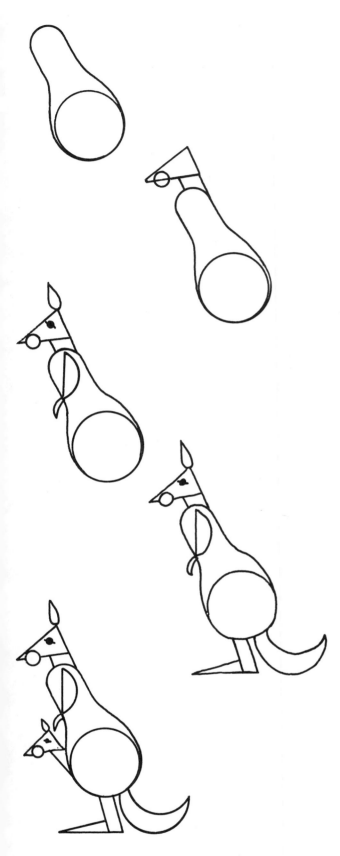

How to Draw a Kangaroo

1. Draw a **pear** shape near the center of your paper for the body.
2. Draw a large **circle** for the haunch.

3. Draw a **rectangle** for the neck.
4. Draw a **triangle** for the head. Draw a small circle for the mouth.

5. Draw an eye as you have before. Draw a **teardrop** shape for the ear.
6. Draw a **half circle** for the arm. Add a very small **crescent** shape for the paw.

7. Draw a rectangle for part of the leg. Draw a triangle for the foot.
8. Draw part of a crescent shape for the tail.

9. Draw a small triangle for the pouch.
10. Add the baby if you want to. Draw the baby's head following the same directions you used for the mother's head.

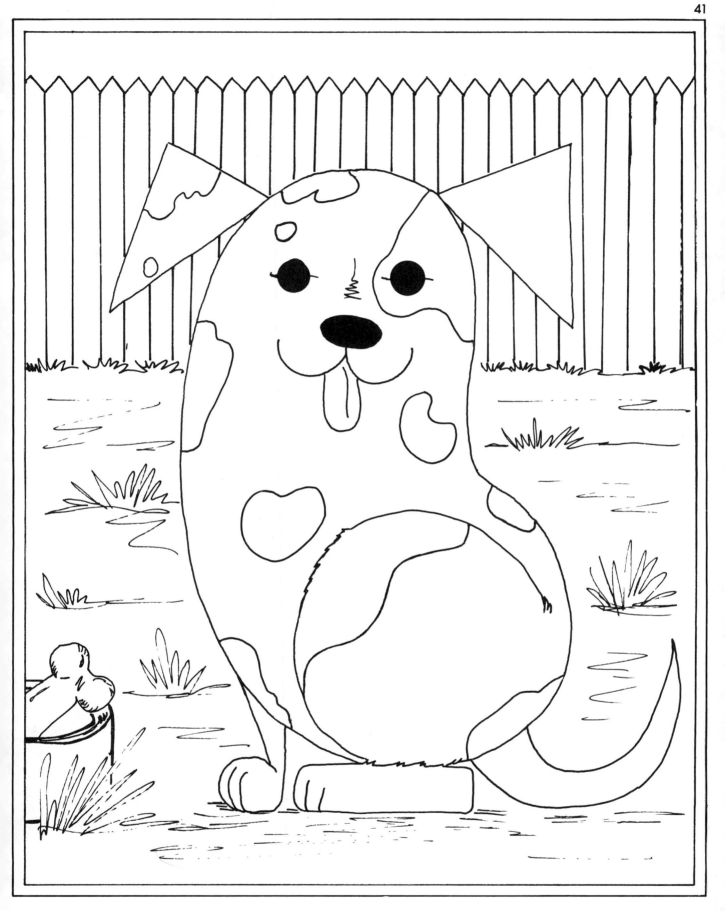

Dog

Dot · to · Dot Picture

Connect the dots to draw this animal.
Begin at 1, where you see a star.
Follow the dots in order.

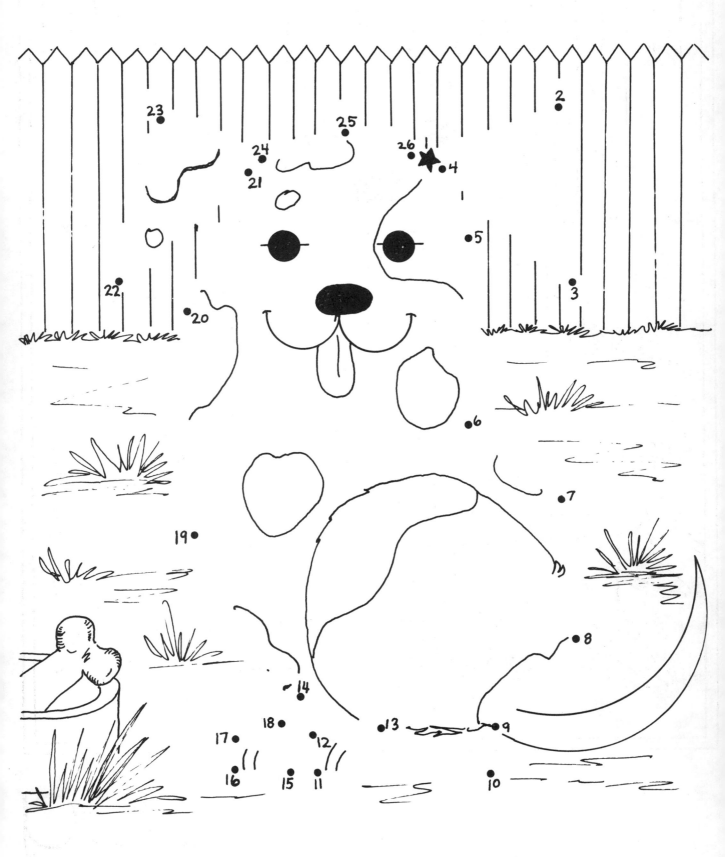

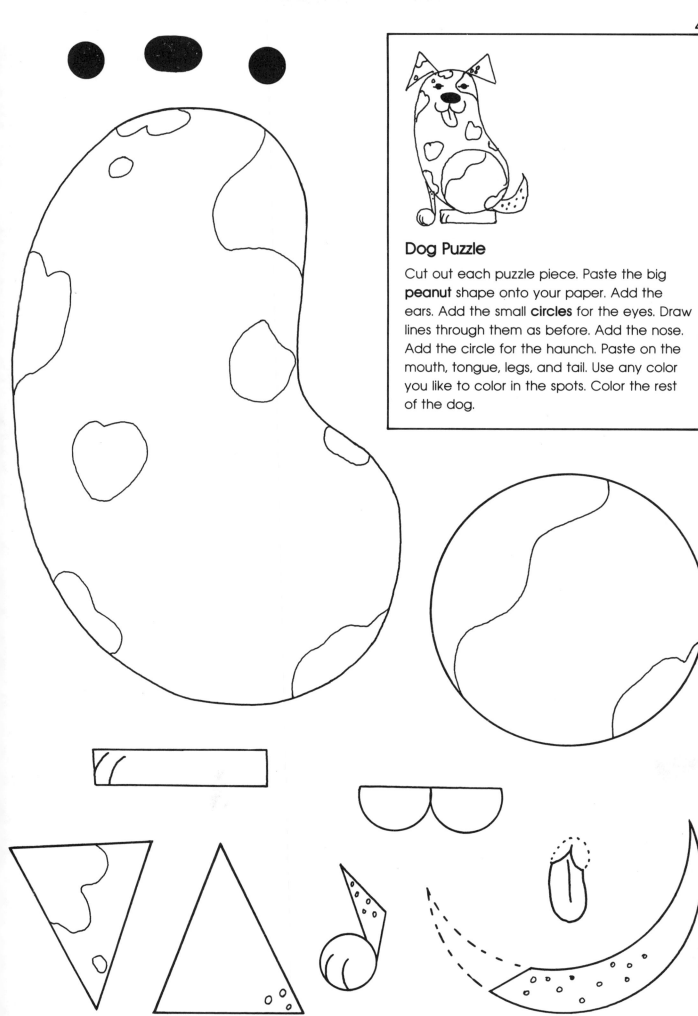

Dog Puzzle

Cut out each puzzle piece. Paste the big **peanut** shape onto your paper. Add the ears. Add the small **circles** for the eyes. Draw lines through them as before. Add the nose. Add the circle for the haunch. Paste on the mouth, tongue, legs, and tail. Use any color you like to color in the spots. Color the rest of the dog.

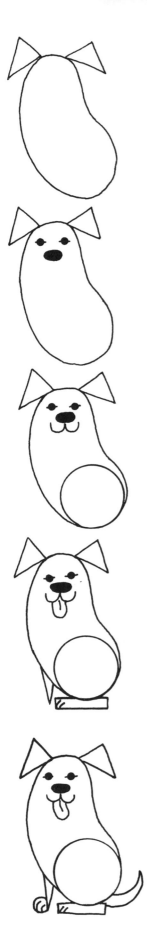

How to Draw a Dog

1. Draw a **peanut** shape near the center of the paper.
2. Draw two **triangles** for the ears.

3. Draw two **circles** for the eyes. Draw lines through the eyes as before. Fill in the circles.
4. Draw an **oval** for the nose. Fill in the oval.

5. Draw a large circle in the lower part of the dog's body to make the haunch.
6. Draw two small **half circle lines** to make the dog's mouth.

7. Draw part of a peanut shape for the tongue. Draw a line down the center of the tongue.
8. Draw a **rectangle** for the back leg. On it draw short, curved lines for toes.
9. Draw lines to make a triangle for the front leg.

10. Draw a circle for the front foot. Draw lines for the toes.
11. Draw part of a long thin **crescent** for the tail.

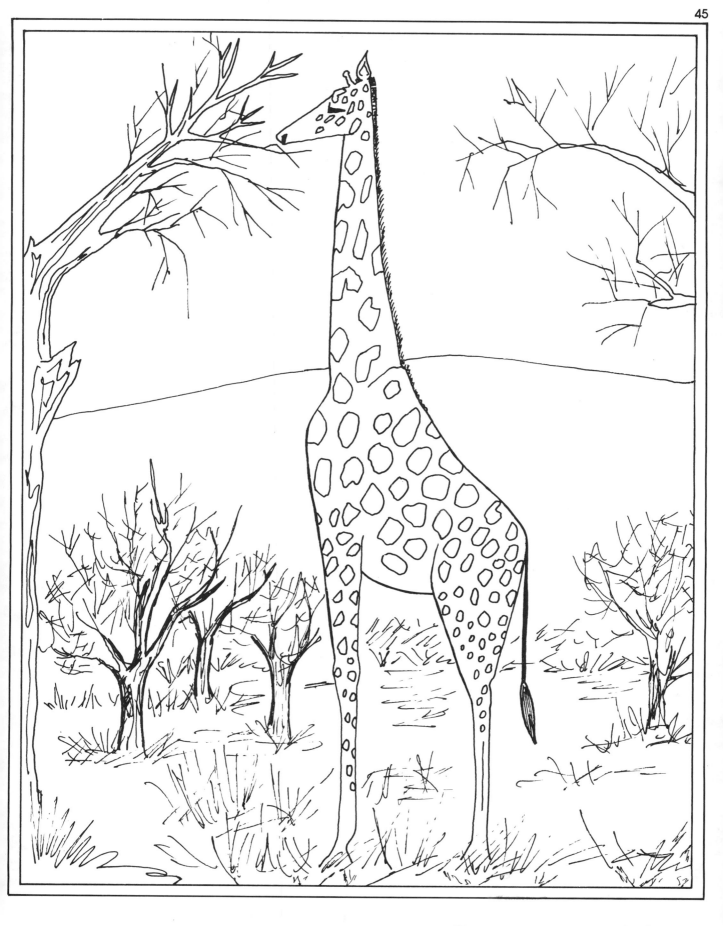

Giraffe

Dot · to · Dot Picture

Connect the dots to draw this animal.
Begin at 1, where you see a star.
Follow the dots in order.

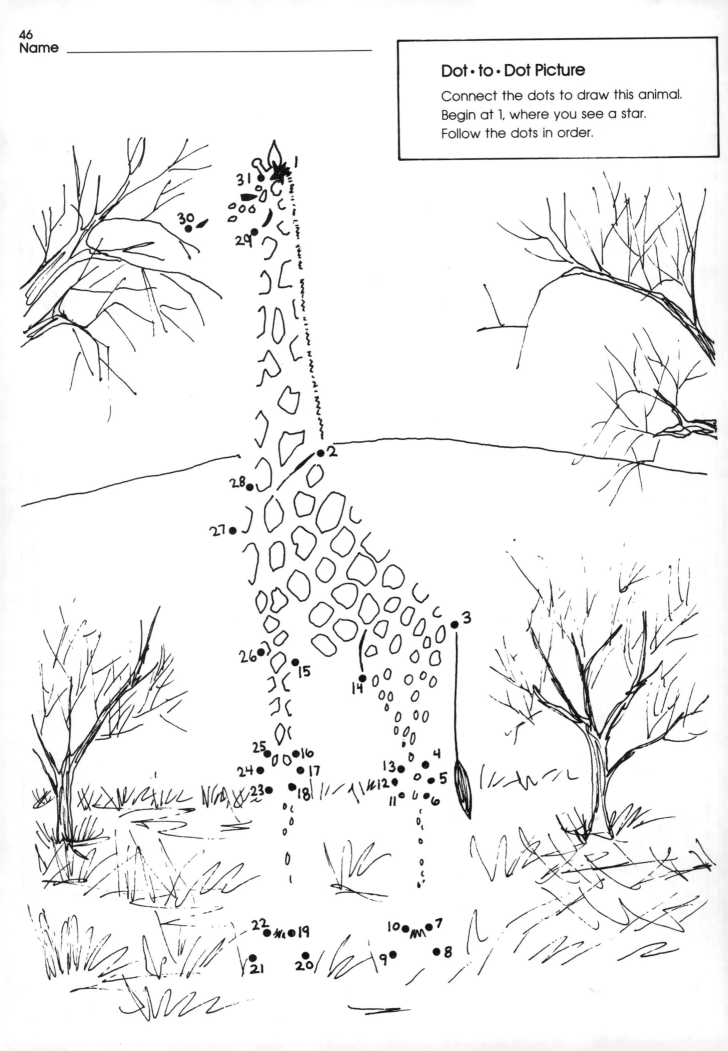

Giraffe Puzzle

Cut out each puzzle piece. Paste the large **oval** near the center of your paper. Add the pieces for the neck, head, and ear. Add the horn. Paste on the legs and feet. Draw a **straight line** and add the black **teardrop** for the tail. Color your giraffe.

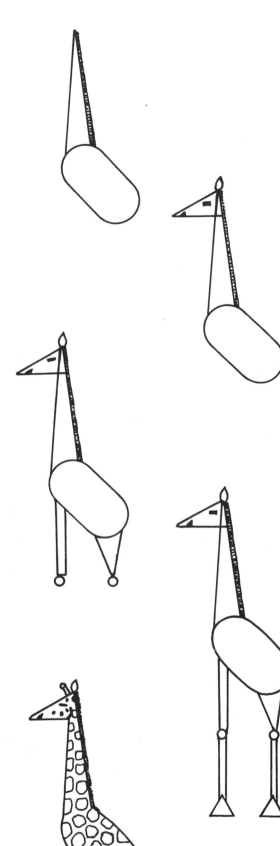

How to Draw a Giraffe

1. Draw an **oval** near the center of the page.
2. Draw a long, thin **triangle** for the neck. Add short lines for hair along the back edge.

3. Draw a triangle for the head. Draw a small **triangle** for the nose. Draw a small, thin **rectangle** for the eye and fill it in.
4. Draw a **teardrop** shape for the ear.

5. Draw a long, skinny rectangle to make the upper part of the front leg. Draw a triangle for the back leg.
6. Draw two small **circles** for the knees, one on the front leg and one on the back leg.

7. Draw the lower parts of both legs by making long, skinny rectangles.
8. Draw one small triangle for each foot.

9. Draw spots on the body, neck, and legs.
10. Draw a line with a teardrop shape at the end for the tail. Fill in the tear shape.
11. Draw a short thin rectangle at the top of the head. Add a small circle on the end of the rectangle for the horn.

Horse

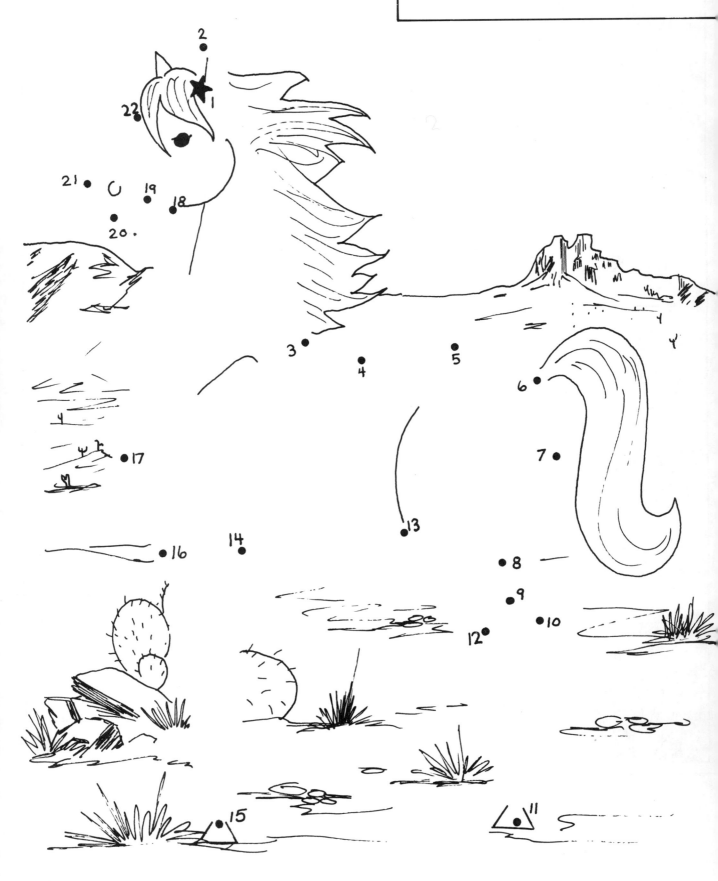

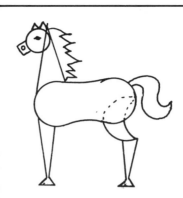

Horse Puzzle

Cut out each puzzle piece. Paste the large **peanut** shape near the center of your paper. Add the **triangle** for the neck, the **circle** for the head, and the **square** for the nose and mouth. Paste on the ears, legs, and tail. Draw a **zigzag line** along the back of the neck to make the mane. Color your horse.

How to Draw a Horse

1. Draw a large **peanut** shape near the center of your paper.

2. Draw a tall **triangle** for the neck.
3. Draw a **circle** for the head. Make it overlap the top of the neck triangle.

4. Draw a small **square** for the nose and mouth.

5. Draw the eye as you have before. Draw another small circle for the nostril.
6. Draw two small triangles for the ears.

7. Draw part of a **crescent** shape to make the upper part of the back leg.
8. Draw a narrow triangle to make the lower part of the back leg. Draw a longer narrow triangle to make the front leg.

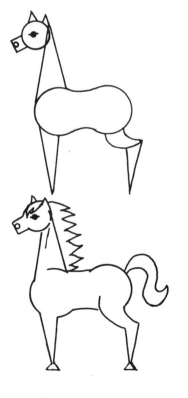

9. Draw two **S lines** a little space apart to make the tail.
10. Draw **zigzag lines** for the mane.
11. Draw two small triangles to make the feet (hooves).

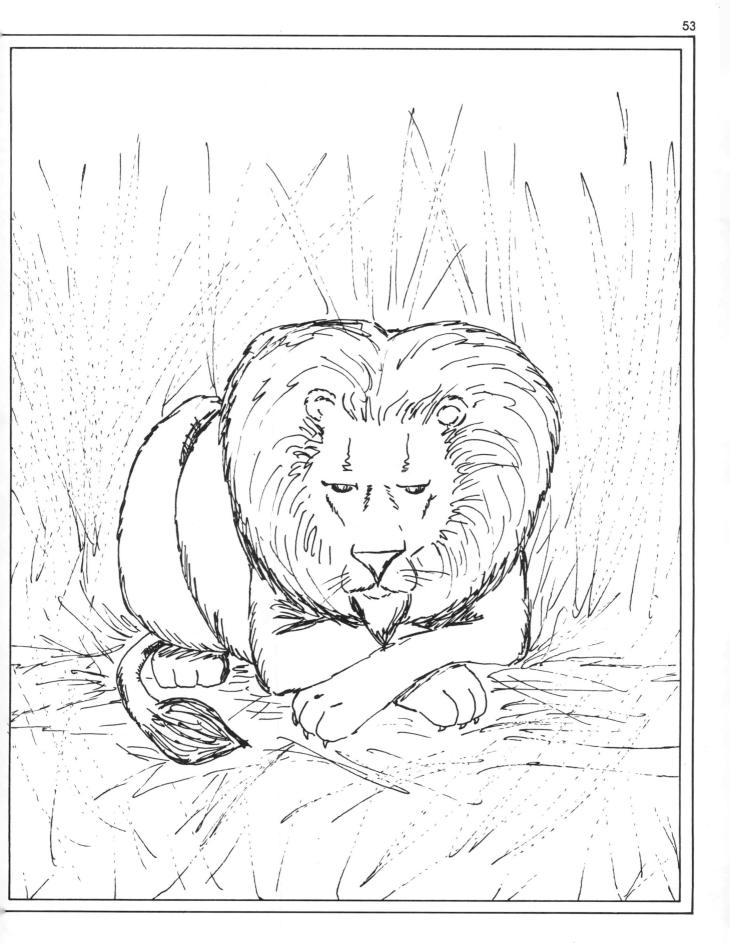

Lion

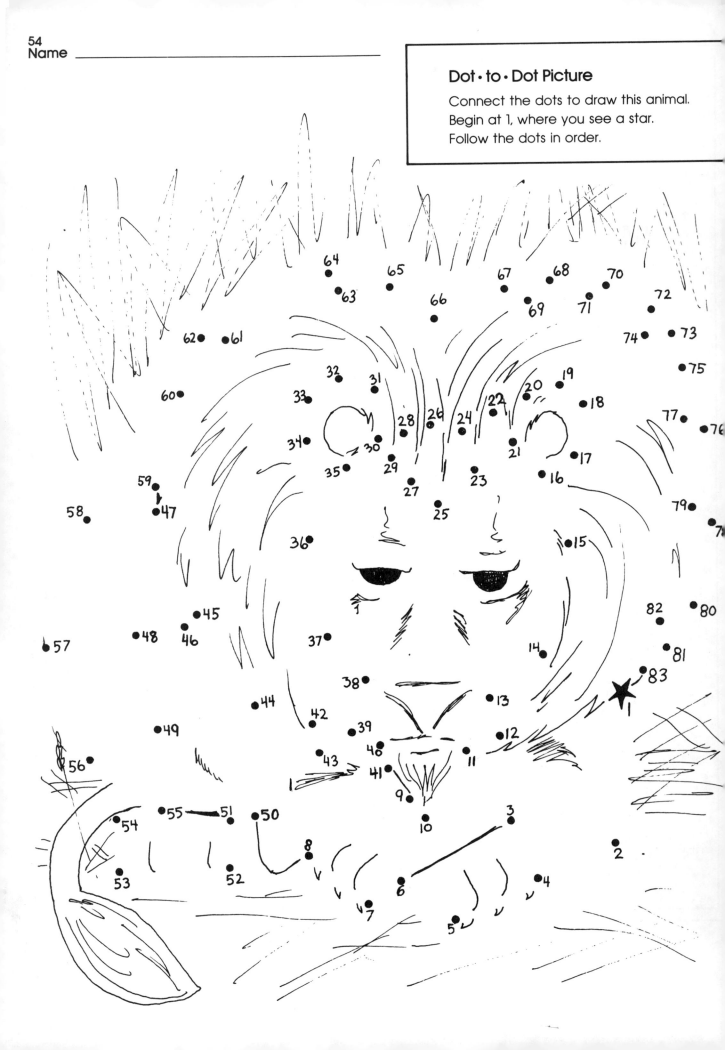

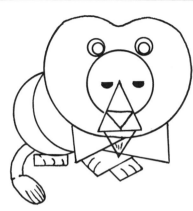

Lion Puzzle

Cut out the pieces of the puzzle. First paste the big **apple** shape onto your paper near the center. Paste on the **circle** for the head. Then paste on the large **triangle** for the nose and mouth. Paste on the small triangle for the nose. Add the legs, body, and feet. Paste on the tail. Paste on the beard last.

Copy both sides of this page.

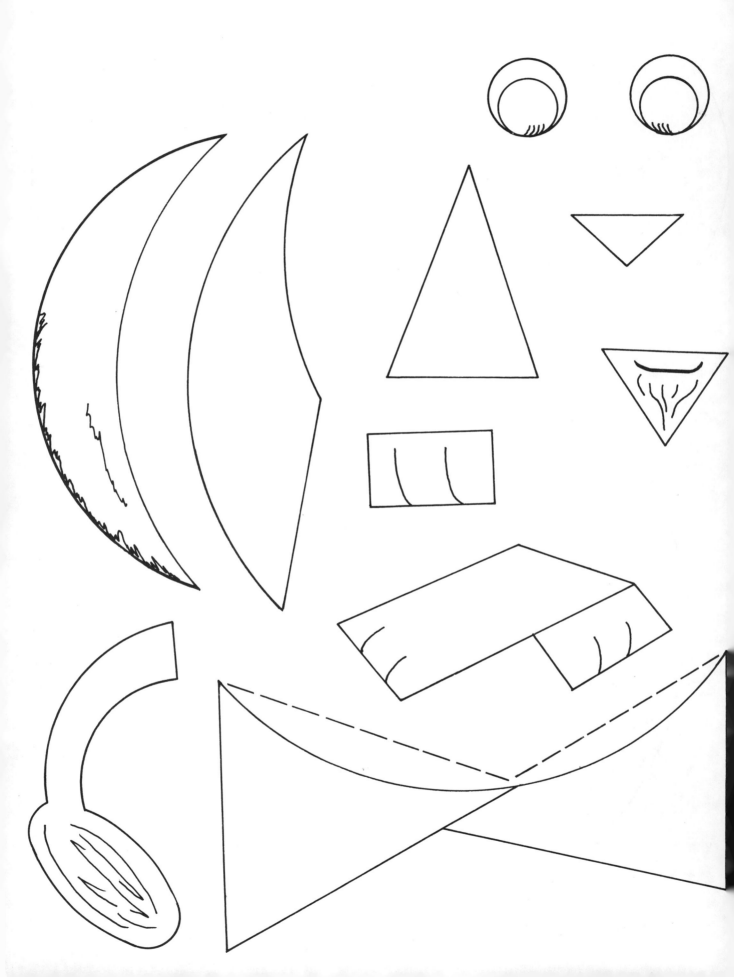

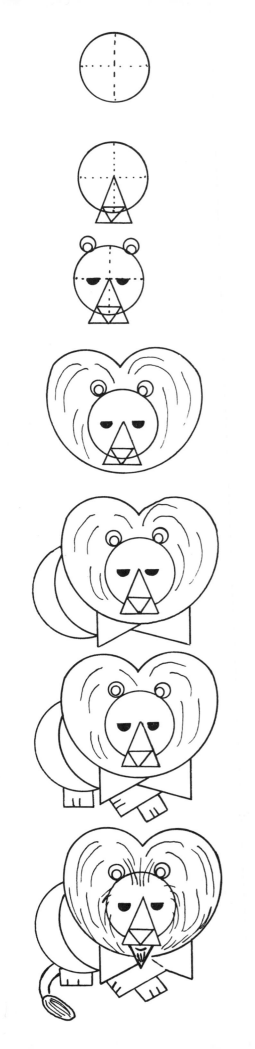

How to Draw a Lion

1. Draw a **circle** toward the right side of your paper. Draw two **dotted lines** with a pencil to divide the circle into quarters.

2. Draw a **triangle** with the point starting at the center dot in the circle. Draw a triangle in the center of the large triangle for the nose.

3. Draw two **half circles** for the eyes and fill in.

4. Draw two small circles for the ears. Draw smaller circles inside the ears.

5. Draw a large **apple** shape using half circle lines around the head, for a mane. Draw some **curved lines** inside the mane to show the pattern of the hair.

6. Draw two triangles for the front legs.

7. Draw a **half circle line** to show the lion's body. Draw another half circle line to show the lion's haunch.

8. Draw a **rectangle** for the back foot. Then draw two more rectangles for the front feet. Draw two short **straight lines** in each rectangle to show the toes.

9. Draw two curved lines with an **oval** at the end for the tail. Draw lines in the oval for hair.

10. Draw a **V** shape for the beard. Add a small curved line for the bottom lip. Add lines for hair in the beard and around the face.

Basic Shapes

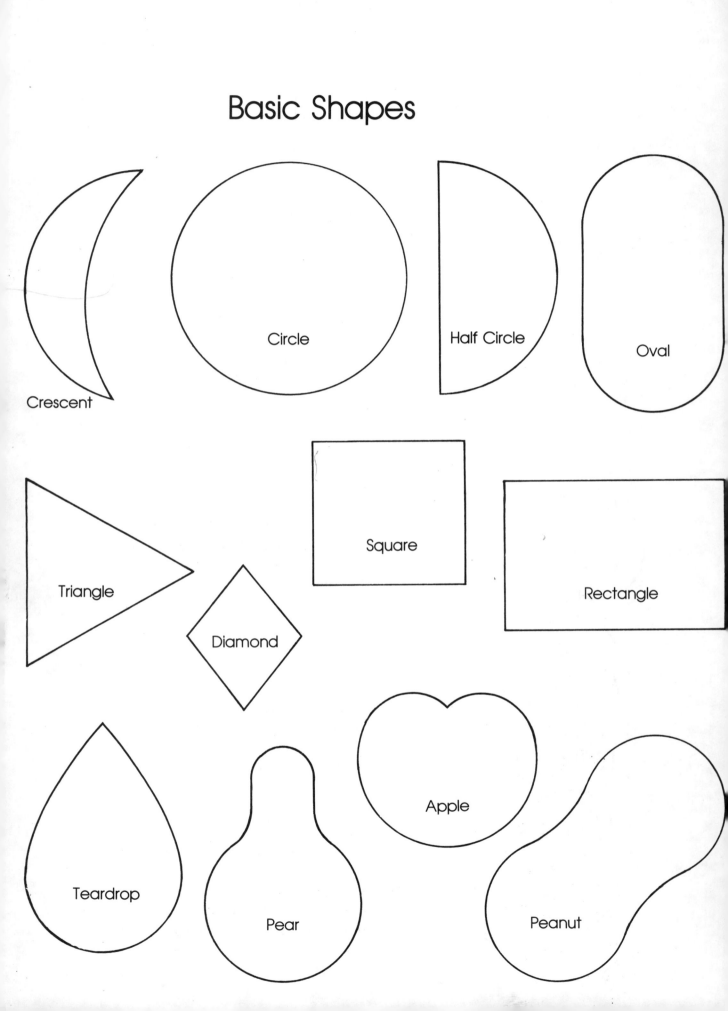

Crescent

Circle

Half Circle

Oval

Triangle

Diamond

Square

Rectangle

Teardrop

Pear

Apple

Peanut